Manga Drawing Books How to Draw Manga Characters Book 1 [B/W]

Learn Japanese Manga Eyes and Pretty Manga Face

By Gala Publication

PUBLISHED BY:

Gala Publication

ISBN-13: 978- 1508697084
ISBN-10: 1508697086

©Copyright 2015 – Gala Publication

By Gala Publication

Table Of Content :

How To Draw
Manga Characters

Anime-Woman

STEP1

STEP2

STEP 3

STEP 4

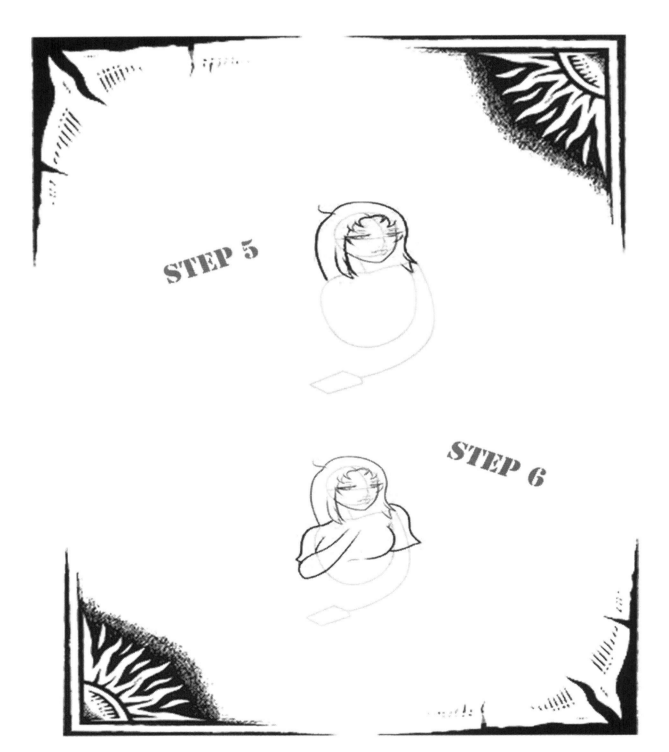

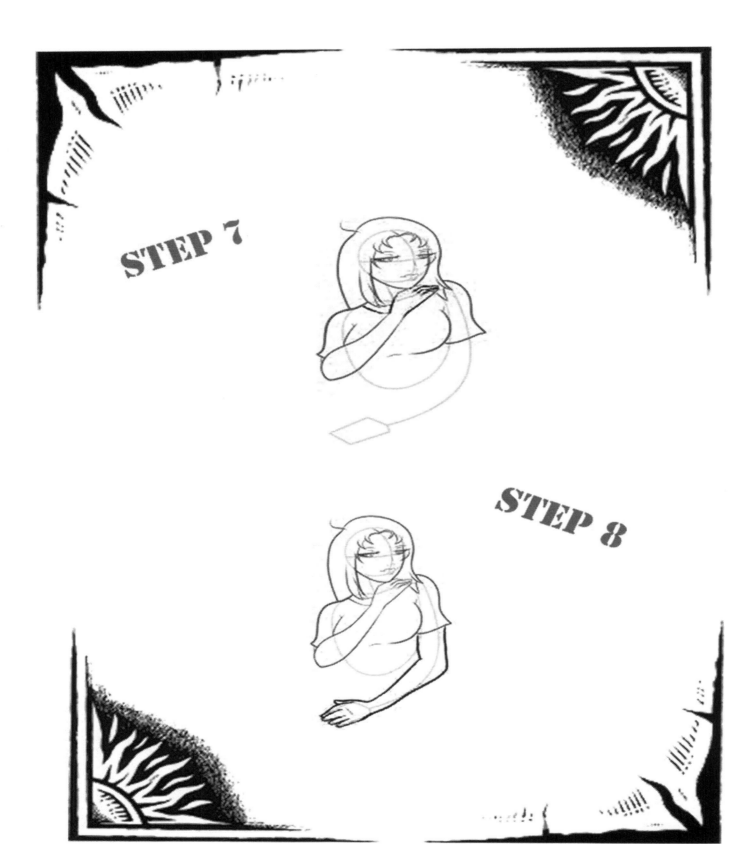

STEP 7

STEP 8

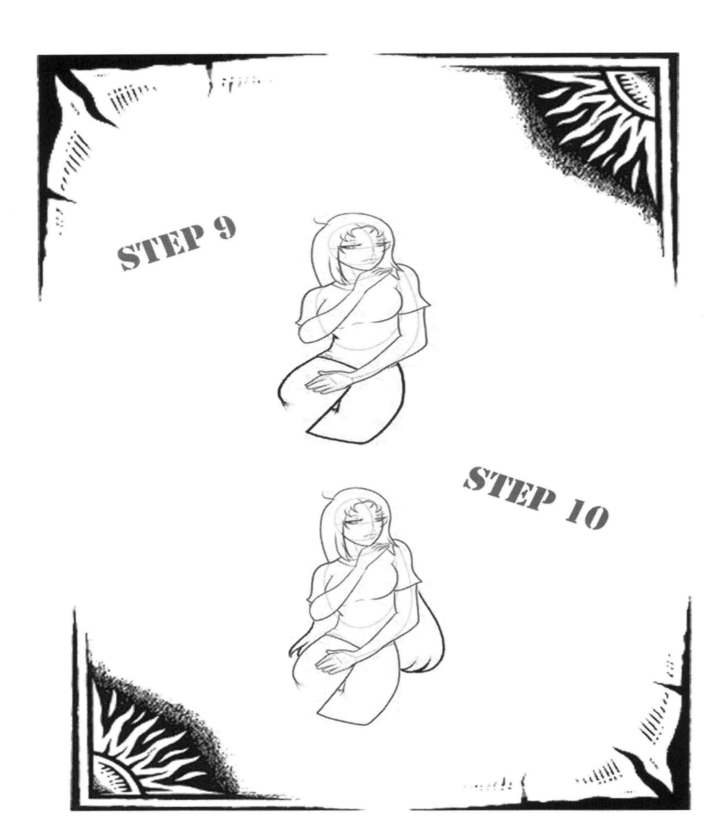

STEP 9

STEP 10

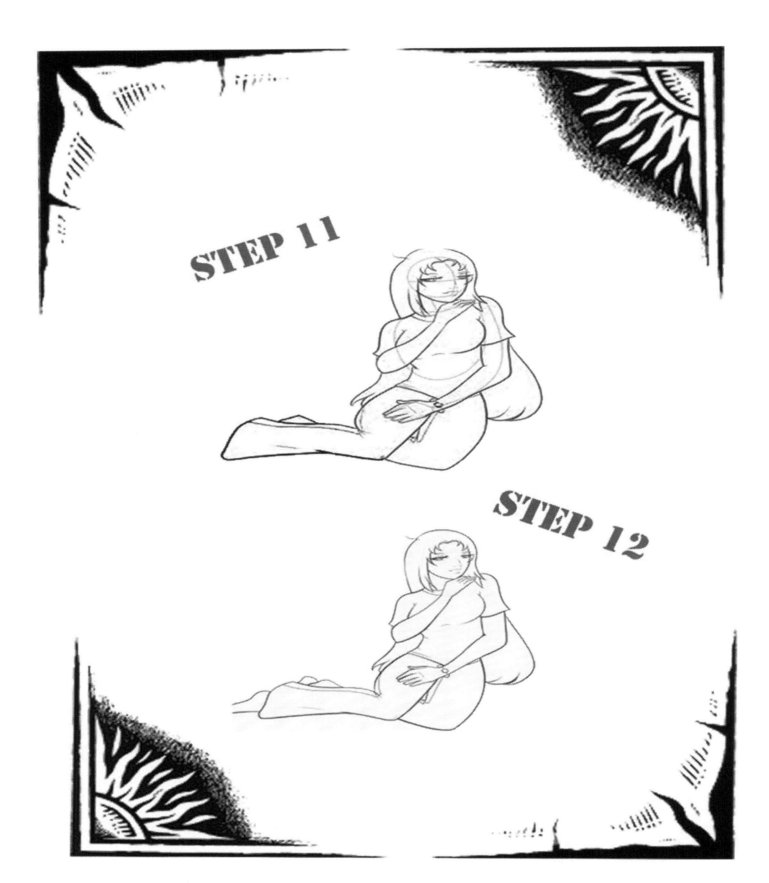

Bishoujo

STEP 1

STEP 2

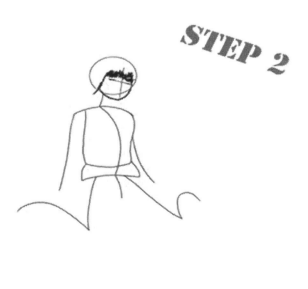

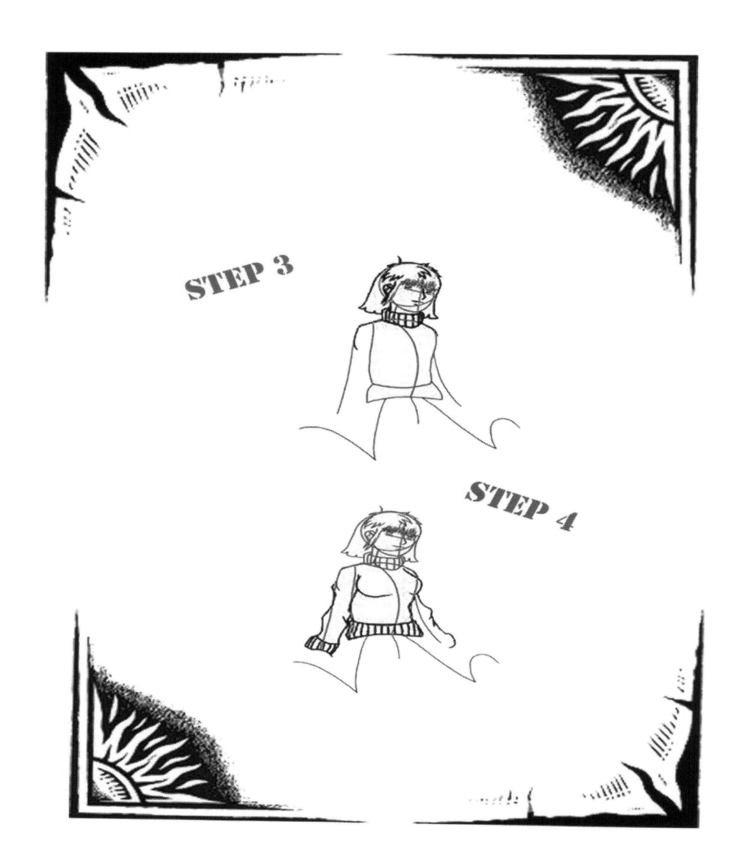

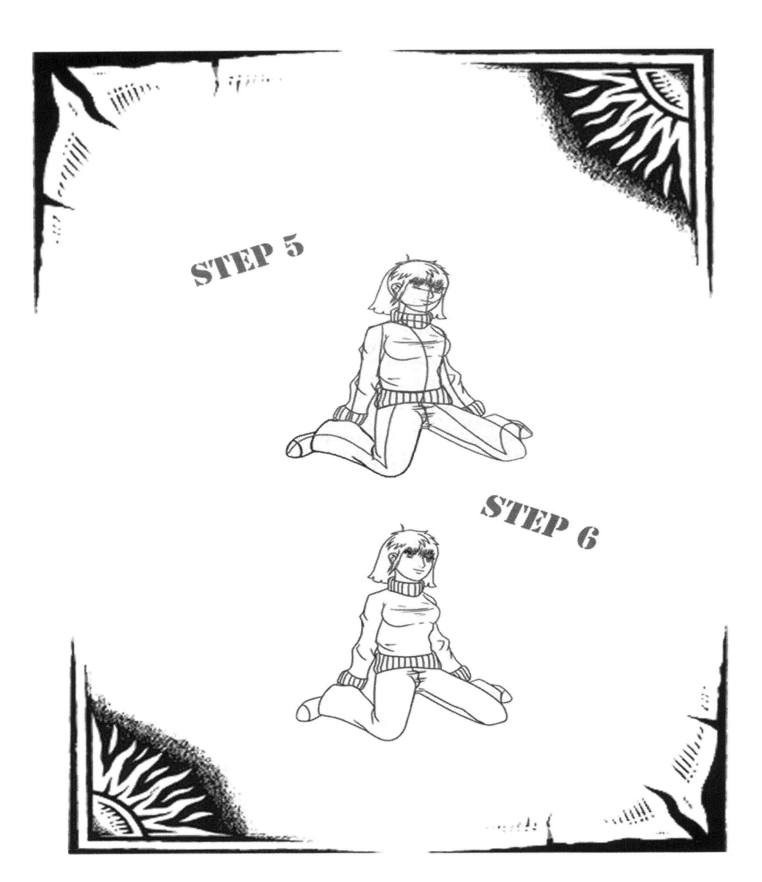

STEP 5

STEP 6

Devil-Girl

STEP 1

STEP 2

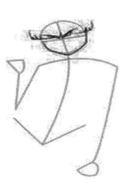

STEP 3

STEP 4

STEP 5

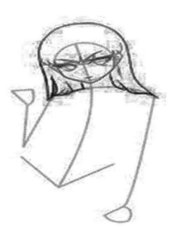

STEP 6

STEP 7

STEP 8

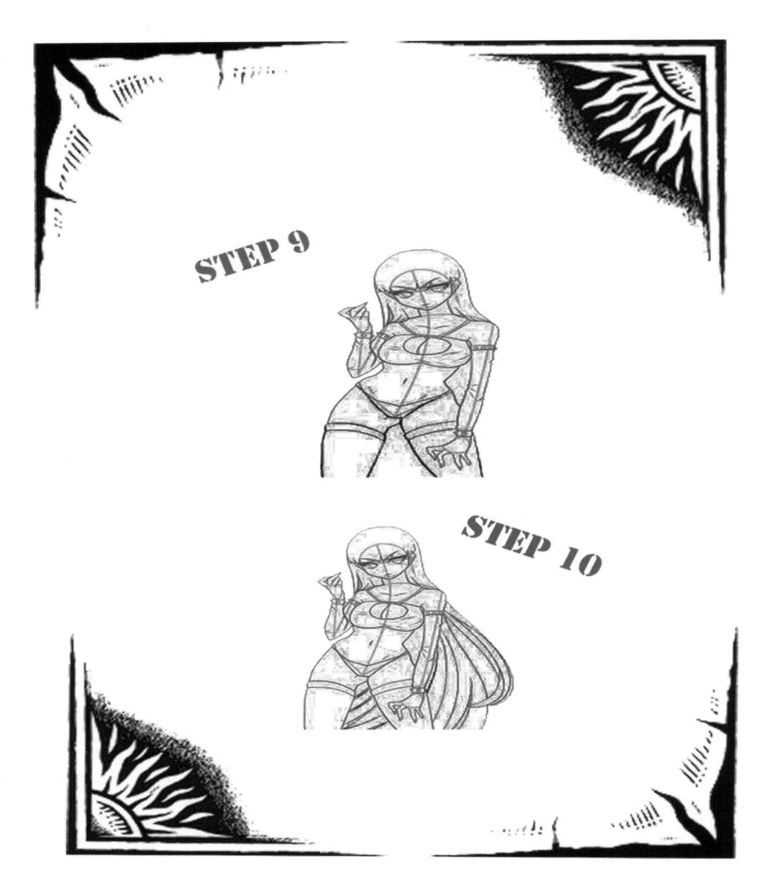

STEP 9

STEP 10

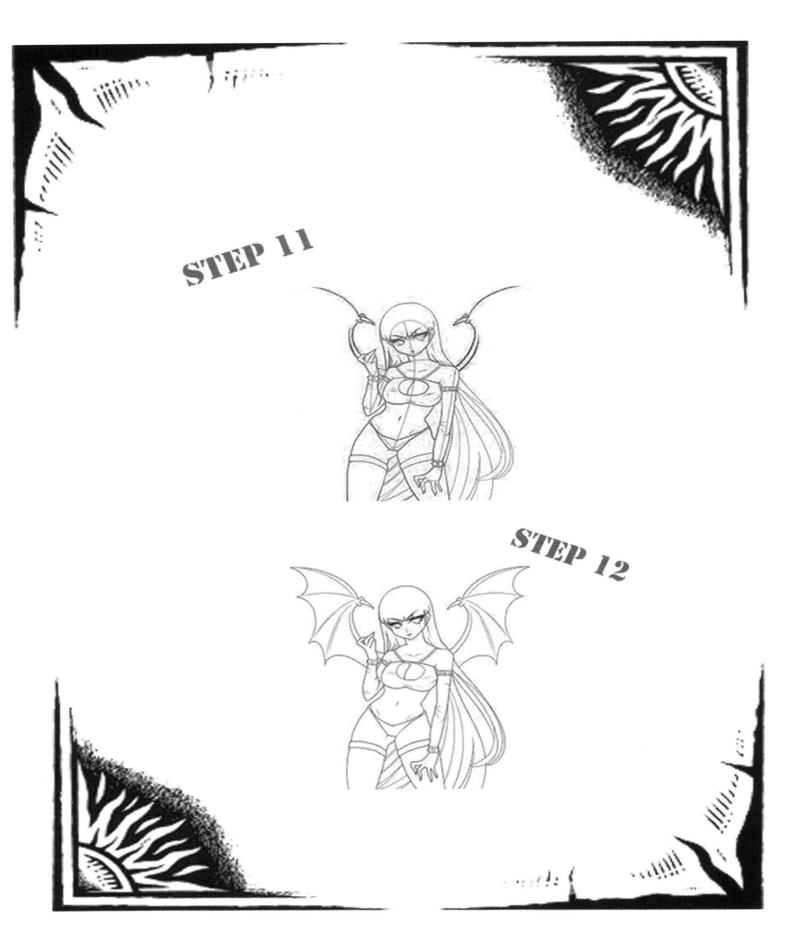

STEP 11

STEP 12

Grape-girl

STEP 1

STEP 2

STEP 3

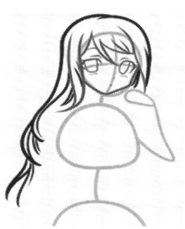

STEP 4

STEP 5

STEP 6

ice-cream-girl

STEP 1

STEP 2

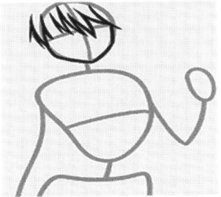

STEP 3

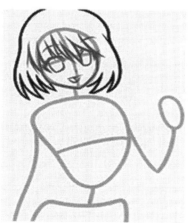

STEP 4

STEP 5

STEP 6

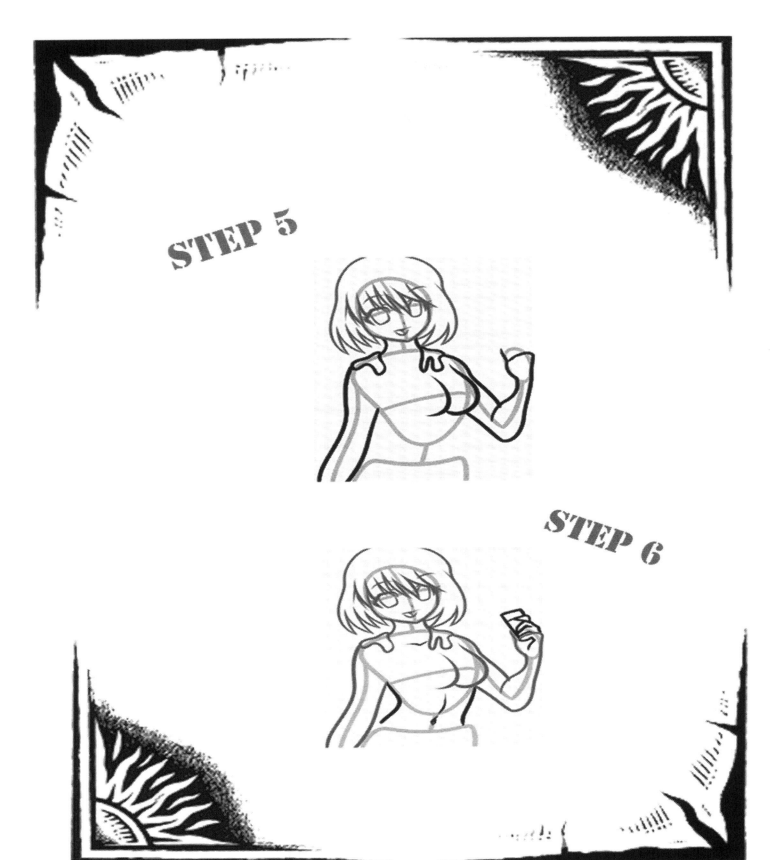

STEP 7

STEP 8

kobato Girl

STEP 1

STEP 2

STEP 3

STEP 4

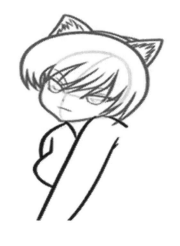

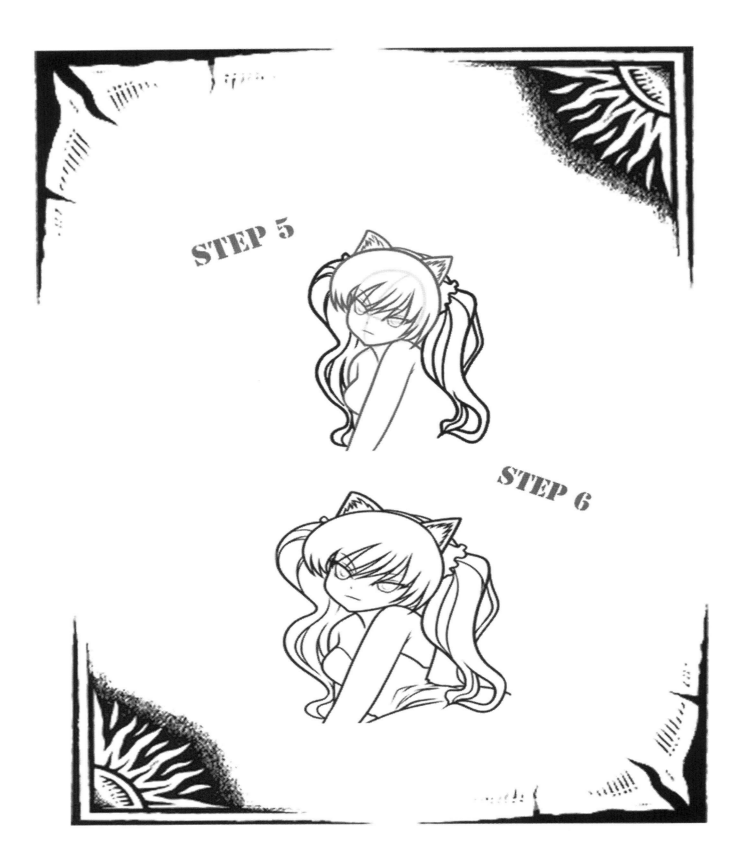

STEP 5

STEP 6

THE END

Printed in Poland
by Amazon Fulfillment
Poland Sp. z o.o., Wrocław